T0083625

MARIANNE VON WEREFKIN

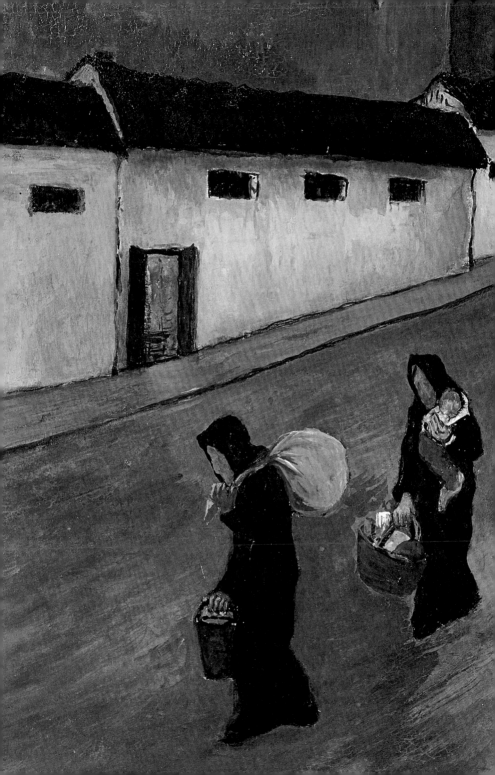

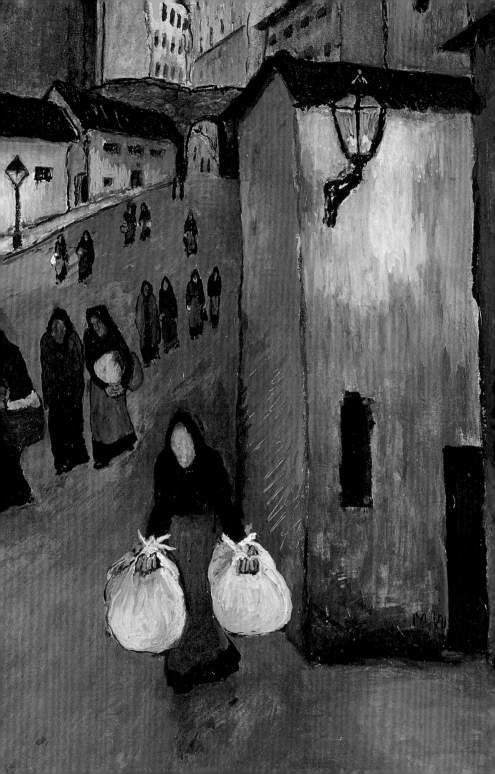

MARIANNE VON
WEREFKIN

Brigitte Salmen

HIRMER

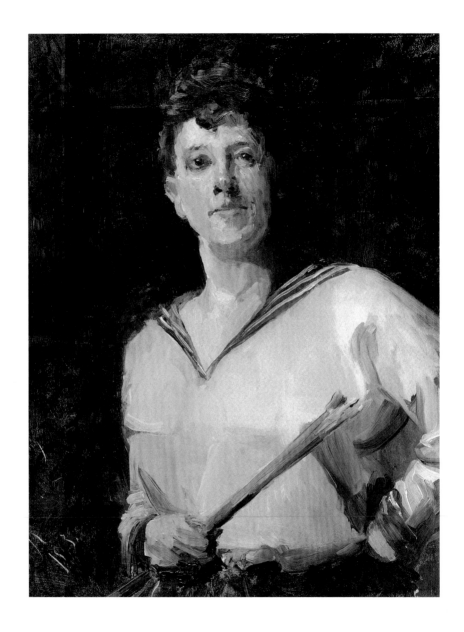

MARIANNE VON WEREFKIN
Self-Portrait in a Sailor's Blouse, 1893, oil on canvas,
Fondazione Marianne Werefkin, Museo Comunale d'Arte Moderna, Ascona

CONTENTS

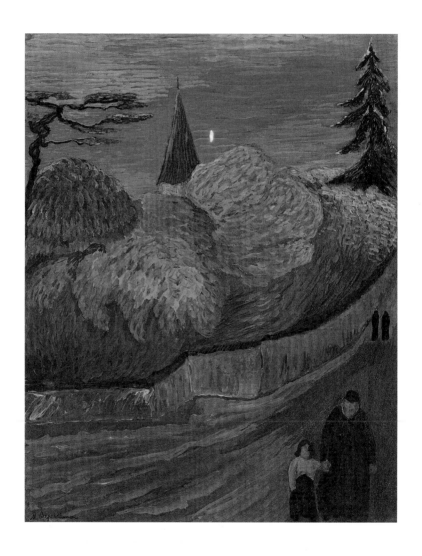

1 *St. Prex Church*, 1914, tempera on paper and cardboard,
Paul Rubattel heirs, St. Prex

"ART ... IS THE SKY ABOVE ME AND THE SOUL IN MY BREAST"[1]

Brigitte Salmen

Marianne Werefkin[2] came from a politically and socially influential family. Her parents were members of the Russian aristocracy, which as a privileged class traditionally held important administrative and governmental offices or high military posts. Marianne was born on September 11, 1860,[3] in the Russian town of Tula, in the official palace of her grandfather, the district governor Pyotr Michailovich Daragan. Her father, Vladimir Nikolaevich Werefkin, had distinguished himself as a young officer in the Crimean War and continued in a military career whose various stages meant repeatedly moving his family. These moves ranged from Belarus and Lithuania to St. Petersburg, where in 1885 he became commandant of the Peter and Paul Fortress. Through her mother, Yelizaveta, née Daragan, to whom she was as close as she was to her father, Marianna gained a first-hand knowledge of painting. Yelizaveta Werefkina had studied privately and was a well-regarded painter of portraits and icons. She welcomed her daughter's interests and artistic leanings and supported them to the best of her ability.

In the Werefkin circle it went without saying that daughters received a comprehensive, Western-style education. In addition to the basics, this included the main European languages and a sound training in cultural and intellectual history. In the 1880s Marianne Werefkin took advantage of

increasingly demanding opportunities for study: in 1879 she had already had two Polish teachers in Lublin, then "finally a good one": P. Heinemann, in Warsaw. In these years she was also repeatedly drawn to Moscow, where she was inspired to further training. Additional stimuli were provided in the summer of 1881 through contact with the St. Petersburg painter and draftsman Ivan Nikolaevich Kramskoi and the painter Vladimir Jegorovich Makovsky. In 1870 Kramskoi had been a cofounder and leader of a separatist movement, The Wanderers (Peredvizhniki); with his genre pictures, Makovsky was also one of the movement's leading representatives. Werefkin shunned the teaching of St. Petersburg's Academy, which was regulated by the Czar and where a classically oriented training was obligatory, determined to observe the reality of everyday Russian life on her own and to paint it in unprettified pictures. In 1883 Werefkin enrolled in Moscow's School of Painting, Sculpture, and Architecture, where she studied under the painter Illarion Mikhailovich Pryanishnikov, another founding member of The Wanderers. In 1879 she had been provided with a new setting for her life and work: the Blagodat estate, near Kaunas in Lithuania, was given to her father by Czar Alexander II in recognition of his distinguished service. It would serve as the family's summer residence from then on, and Marianne happily stayed there, especially after her father built her a small studio. In the fall of 1885 she had to leave Moscow and join her father in his new posting in St. Petersburg, so as to help with his obligatory entertaining in place of her deceased mother. The St. Petersburg Academy was not yet open to women, but she was able to study painting under one of its teachers, Ilja Repin, the most famous representative of Russian Realist painting. She later wrote of him: "He was a man of quite genial gifts. … He loved me and valued me as a person, a woman, and was my most enthusiastic admirer as an artist. He always called me Velázquez. I have many grateful memories of him as my teacher, but I always fought him, at the time out of my instinctive feeling for art—and he would admit I was right."[4]

Werefkin's artistic development went hand in hand with intensive reading. Beginning in the early 1880s she occupied herself with classical literature, history, politics, religion, and theosophy. In the years 1891 to 1895 she particularly sought out Western European publications on physiology, physiognomy, psychology, criminology, and optics, and took an interest in fundamental questions of philosophy and art theory. Naturally she also

2 *The Coach, Approach to the Estate Blagodat near Kaunas, Lithuania*, ca. 1880–87, oil on canvas, whereabouts unknown

consulted books on art and artists, became familiar with Impressionist painting, and kept up with contemporary trends, especially in France, that provided her with inspiration and topics for discussion. She also maintained an active social life in St. Petersburg, regularly hosting large numbers of artists.

The paintings Werefkin produced in her roughly sixteen years in Russia show how deeply rooted she was in the realistic painting long dominant in Russia and how closely she adhered to it in style and in part in subject matter. Although a member of the Russian upper class, she did not look away from the precarious situation of the poorer classes but rather respected them and shared the Realists' ethical concerns. In the early 1880s she already produced works of obvious social criticism, picturing the blatant contrast between rich and poor, as in the painting *Die Kutsche, Zufahrt zum Gut Blagodat* (*The Coach, Approach to the Estate Blagodat*, 2). The only surviving painting from the year 1881, the *Porträt der Vera Repin*

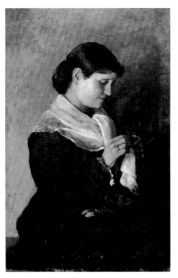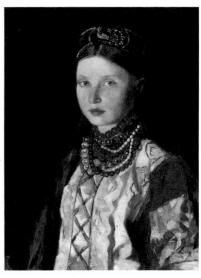

3 *Portrait of Vera Repin*, 1881, oil on canvas,
PSM Privatstiftung Schlossmuseum Murnau,
on permanent loan to the Schlossmuseum
Murnau

4 *Girl in Russian Costume*, ca. 1885, oil on canvas,
private collection

(*Portrait of Vera Repin*, 3) already shows the young painter's artistry and maturity. Vera Repin is pictured before a dark background wearing a dark-brown dress and a light-colored shawl. The young woman appears to be especially sensitive, and cautiously smiles as she knits a child's stocking. The dominant rich brown is delicately accented by light falling in from the left. In her other portraits Werefkin was equally concerned to depict the essential nature of her subjects. Her bust portraits capture her models with empathy, their personal appeal. From the early dark, tonal atmospheres she soon switched to more detailed execution and livelier coloring, as seen in the *Mädchen in russischer Tracht* (*Girl in Russian Costume*, 4) and *Porträt der Mutter* (*Portrait of My Mother*, 5).

In the mid-1880s Werefkin developed a relationship with the physician Dr. Vasily Vladimirovich Lesin, and in the following years he was her constant consort. After seven years he finally asked her father for her hand, but it was too late, for on the previous day Werefkin had decided on the young officer Alexei Jawlensky, whom she had met in the spring of 1892 through Ilja Repin.[5] He was to play a dominant role in her life from then on.

5 *Portrait of My Mother*, 1886, oil on canvas,
whereabouts unknown

6 *The Reader*, 1893,
oil on canvas,
whereabouts unknown

By then Werefkin's work was receiving increasing public recognition. Already in 1890 she was included in the first exhibition of the St. Petersburg artists' society, and in 1892 she showed several paintings in a show by The Wanderers, of which she had meanwhile become a member, that toured through Russia and Poland.[6] Repin was also full of praise; in 1893 wrote Marianne's father about her as-yet-unfinished painting *Der Vorleser* (*The Reader*, 6): "Now, finally, it is in every way a masterpiece; here one can see a great artistic gift; looking at it, one thinks to see in it the tradition of the great masters of Italy and Spain."[7] In this and other compositions of the time, she captured the distinct individuality of her subjects with a sensitive grasp of their personalities, and in figural scenes rendered with subtle chiaroscuro and finely nuanced, balanced coloring lifelike individual portraits. She was not interested in impressionistic views like the landscape and plein air painting of her colleagues, but rather the sensitive recording of the physiognomies of specific contemporaries. Her painting, schooled in the tradition of the great seventeenth-century Netherlandish, Flemish,

and Spanish masters, was so outstanding that she was admiringly referred to as the Russian Rubens, Rembrandt, Velázquez, or Zurbarán.[8] With justification: in her 1893 *Selbstbildnis in Matrosenbluse* (*Self-Portrait in a Sailor's Blouse*; see p. 8), now executed in a new style with broad, fluid brushstrokes and light colors, she could picture herself, both in her pose and expression, as a self-confident woman and painter, seemingly on top of the world.

TURNING POINT

By then Werefkin was closely aligned with Alexei Jawlensky, both personally and through painting. The son of a far less well-off officer's family, Jawlensky had discovered a love of art at the age of sixteen, and begun studying painting in 1889 while still in officer's training. Soon after they met in 1892 they began living together, and she strongly encouraged him in his further study of painting. She declined to marry him in part in view of his considerably lower social rank and in part because it would have meant losing her generous allowance—not to mention the fact that there were problems in their relationship. By the time they had been together for three years they were having major disagreements. Jawlensky felt that Werefkin was too controlling, though—quite against her nature—she had tried to adapt to his expectations. In March 1895 Werefkin concluded "that emotionally I'm just as lonely as ever, for my ultimate attempts to find some resonance in another human soul these past three years have failed like all the others. … For three years I have walked in step with him, opened door after door for him, shown him his talents, the mystery of art, burying myself behind feminine weakness, pretending to be studying on my own and tolerating his mistreatment of me."[9] The situation only worsened once Jawlensky fell in love with Werefkin's young chambermaid, Helene Nesnakomoff.[10]

In addition to the tremendous conflicts in their relationship, Werefkin was facing an artistic crisis. In this late nineteenth-century time of upheaval, when there was widespread pessimism about the future and an uncritical faith in technology, and under the impression of avant-garde trends, especially in French painting, the goals of Realism no longer struck her as progressive. At the same time, she became profoundly uncertain about

whether she was a true artist, a role she now questioned for one of her gender: "I'm a woman, I'm empty of all creativity, I can understand everything yet can't produce anything."[11] And still years later, in 1902, she confessed, exposing both her uncertainty and her inner conflict: "<u>I want to work</u>. It's an obsession. From the depth of my heart I am filled with a fierce desire to work with paint. I study figures passing before my eyes with an unbelievable intensity. Let us consider what could be done. Why not continue to work? I've lost my confidence. The habit of putting myself in second place has done the rest. Am I a true artist? Yes, yes, yes. Am I a woman? Alas, yes, yes, yes. Can the two go hand in hand? No, no, no."[12]

In this impossible situation she came to the conclusion that art was the higher good, and that she could best serve it by promoting Jawlensky's talent and giving up her own painting. She would stay with him so as to realize indirectly, through him, her artistic aims. In an extreme demonstration of emotional strength she resolved to punish "the one who destroyed the artist in me" and maintain power over him by making herself subservient, by promoting his art and his resulting recognition. This would be her compensation for the "degradation" she had suffered from him.[13]

She gave in to Jawlensky's urging that they leave Russia so he could undertake further study abroad. The fact that her father died in January 1896 made it easier for Werefkin to part from her Russian homeland. In October 1896 the couple moved to Munich—together with Helene Nesnakomoff.

MUNICH AND MURNAU

This change of scene would spark the development of a distinctly new way of painting for Werefkin, one that would become visible only much later, when in 1906, after ten years of abstinence, she again took up her painting.[14] Along with Jawlensky, she first looked for new inspiration in Munich, an art capital that in those years attracted artists from all over Europe, and where they formed the most varied groupings and schools. Among them was the popular school of the painter Anton Ažbe, who represented a kind of Neo-Impressionist painting.[15] While Jawlensky brought his art to stylistic and technical perfection under Ažbe's instruction, Werefkin concerned

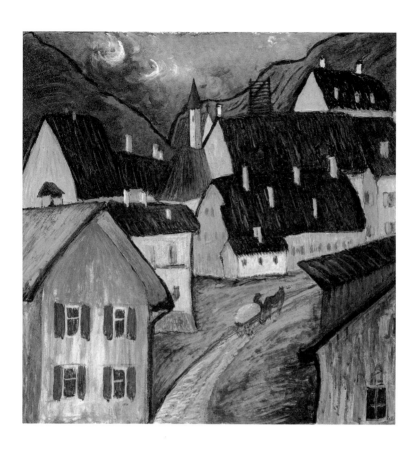

7 *Evening in Murnau*, 1907/10, tempera on cardboard,
Schlossmuseum Murnau

herself exclusively with theoretical issues and painting techniques. She enjoyed intense discussions with friends and colleagues, and soon a veritable salon came into being in her Giselastrasse apartment, a focal point of Munich's artistic life. There she founded the Brotherhood of St. Luke, named after the association of German artists that had worked in Rome since 1810. That earlier group had sought to free itself from academic, neoclassical painting hoping to regenerate art. Werefkin took its ethical stance as a model and declared: "Art follows two paths: realism, the servile imitation of nature, readily understood by the public and met with applause—and the reproduction of nature, nature seen through an impression or through feeling, personal art, through all time the ideal art of genius."[16]

Through the years, prominent literary, musical, and theatrical figures frequented Werefkin's salon in addition to numerous artists, many of whom belonged to the Russian avant-garde. With her enormous personal and intellectual charisma she was, as later recalled by an admiring Gustav Pauli, art historian and director of the Bremen Kunsthalle: "the center, in a sense the transmitter of almost palpable waves of energy. ... [She] dominated not only the conversation, but her entire surroundings."[17] One of Werefkin's preferred conversational partners was the Austrian graphic artist, illustrator, and writer Alfred Kubin, whose pen drawings fascinated her. She saw in him, with his almost unbounded self-esteem and ominous visionary worlds, a person who understood her own way of thinking. Another member of her circle was the intellectually demanding painter and theorist Vasily Kandinsky. Though Werefkin was initially somewhat critical of him, they soon became increasingly close friends.

If one studies both Werefkin's notes and Kandinsky's early writings, it becomes apparent that in their art-theoretical deliberations she was the innovator. This is understandable, for unlike Kandinsky, who started out in Munich as an autodidact, she had been intensively engaged with such questions since the 1880s and had already produced a recognized body of work in Russia. "Art is a worldview that finds expression in the forms suggested by its technical mediums: the sound, the color, the form, the line, the word. The peculiarity of art is that its idea is most intimately bound to the form with which it is required to express it; artistic creation is an idea conveyed through form."[18] For Werefkin, as she emphasized again and again, emotion was the basis of art, and it was color that played the decisive role. She pondered the characteristics of painting techniques and the

emotional effect of colors and their combinations, explaining the function of colors and how they related to form.[19] Whereas she never considered publishing her ruminations, beginning in 1908 Kandinsky developed increasingly expansive theories that he published in 1911/12 in his groundbreaking book *Concerning the Spiritual in Art*.[20] Some of the ideas presented in it had been addressed in her personal notes as early as 1897 and discussed in the St. Luke circle but not taken up by her friends. This was the case, for example, with her notions, expressed as early as the beginning of the century, regarding surface, form, colors, and the deployment of black and white.[21]

HOPES AND DISAPPOINTMENTS

In late 1898 life with Jawlensky again became highly stressful at times, for his erotic escapades preyed on her mind. Her efforts with regard to Jawlensky's artistic development became more difficult after he left the Ažbe school in 1899 and continued to work without further professional guidance. He repelled Werefkin's endeavors to intervene in his work, and his dissatisfaction affected her greatly. She began to doubt whether it was possible to live with him any longer, and frequently considered a final separation. With that in mind she traveled to Lithuania in 1901. Having relented and returned to Munich, she found it necessary go back to Lithuania at once together with Jawlensky and his beloved Helene, for the girl was pregnant. She was only sixteen, so the identity of the father could not be revealed. Thus, to wait out the birth of the child, they stayed at Anspacki Palace near Vilnius until November of the following year. Jawlensky's son, Andreas, would subsequently be passed off as his nephew.

An escape from her continuing personal and artistic crisis was provided in the late summer of 1903 by an extended trip to Normandy and Paris with her friend the Russian painter Alexander von Salzmann. While in France they visited the Louvre and saw paintings by Manet, Monet, Whistler, Renoir, Zuloaga, and Cézanne. Under these impressions Werefkin began thinking about the intrinsic value of colors in new ways.[22] She described the principles that had become clear to her: (1) on "color harmony"; (2) on "surface—for its development"; and (3) on "boundaries—drawn solely in agreement with the configuration and strength of the colors."[23] And she

envisioned color assignments wildly diverging from nature: "I'm considering whether one might derive the same impression of reality from the triad red tree, blue earth, and green sky as from the conventional combination of green tree, red earth, and blue sky." This struck her as conceivable, and she concluded: "All efforts to quote, to represent life photographically— are senseless."[24] Here, as early as 1903, she came up with the essential pictorial features of future Expressionist painting, which she would employ herself in her first Murnau pictures in 1907 (followed by Jawlensky, Kandinsky, and Gabriele Münter the next year).

In the summer of 1904 Werefkin and Jawlensky stayed for three months in Reichertshausen an der Ilm. Impressions she gathered there—like those from Murnau—would leave their traces years later, when she resumed painting. In the spring of 1906 she set out for France once again, this time for a stay of some ten months, accompanied by Jawlensky, Helene, and Andreas. They spent the first months in Brittany, where the Pont-Aven painters, among them Émile Bernard and Paul Gauguin, had lived and worked. In his landscapes and figural paintings Gauguin had produced a new picture structure in flat colors with clear contours and simplified forms. At the time, Werefkin was far more intrigued by this new way of painting—and the poster-like imagery of Henri de Toulouse-Lautrec— than Jawlensky was. She soon commented: "Color dissolves existing form. ... Color determines form."[25] She had come to these important new conclusions even without having seen firsthand the scandalous works of the Fauves in the 1905 Salon d'Automne.

In October 1906 Werefkin journeyed with the painter Robert Eckert, Helene, and Andreas to Provence, staying near Marseille. Jawlensky followed at year's end. Together they visited Arles, where their revered Vincent van Gogh had lived. In her continuing engagement with fundamental compositional questions and under the impression of innovative works by her French colleagues, Werefkin processed further insights and more and more felt compelled to create art herself. She determined to paint once again.[26]

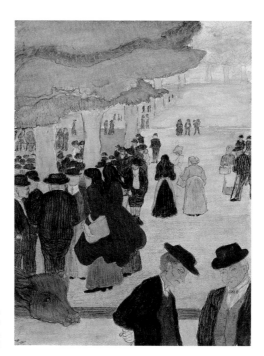

8 *Livestock Market*,
mixed media
on cardboard,
private collection

"ART RECEIVES ME AGAIN"[27]

In Murnau in 1907 Werefkin suddenly began working in a previously un-
suspected painting style. At first she continued to deploy light hatching
with colored crayons and pastels, for example in *Viehmarkt* (*Livestock
Market*, 8), a technique that lends the picture a graphic quality. But for her
new subject matter she soon arrived at a surprising new flat picture struc-
ture and strong coloring. In her absence from painting for so many years
she had avoided the phases of Symbolist influence, turn-of-the-century
Jugendstil, and Neo-Impressionism that her artist colleagues had had to
work through. Now, in a wholly idiosyncratic way, she put into practice
ideas she had developed over the intervening years in colorful and expres-
sive drawings, gouaches, and paintings.

A study sojourn in Murnau with Kandinsky, Münter, and Jawlensky
beginning in August 1908 brought new, important inspiration. The six

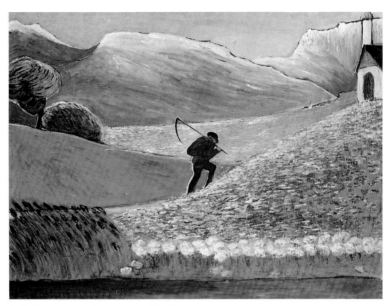

9 *The Reaper*, ca. 1910, tempera on cardboard,
private collection

late-summer weeks the four painters were together also brought decisive
artistic breakthroughs for Kandinsky, Münter, and Jawlensky, a new com-
positional structure in form and colors that would prove transformative
for the art of the twentieth century. Münter would recall: "All four of us
worked hard. We were all industrious," but there are no known comments
by Werefkin about their Murnau stay. In her work, however, especially in a
large number of sketchbook motifs, her intensive engagement with the
locality and its landscape between 1907 and 1910 is apparent (see pp. 70–
77).

Werefkin captured her observations spontaneously in her sketches, but
never transferred them to paintings on the spot. She would return to them,
with changes, in her Munich atelier. Since the previous year her work had
already diverged from that of her companions in content, structure, and
technique. She had begun to reduce her compositions to the most basic
forms, placing them next to one another as large planes, and defining them
with contours in the manner of cloisonné. In this she was adopting the
compositional methods that had characterized Gauguin and the Nabis,

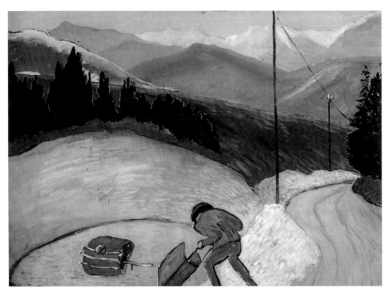

10 *Quarry*, 1907, tempera on cardboard, private collection

which were to a large extent derived from the Japanese woodcuts so highly admired by the Impressionists. In addition to flat and linear structures, at times with poster-like coloring and a preference for overlapping figures and motifs, those prints featured diagonals, views from above, figures seen from the back, and trees as compositional motifs.[28] In her paintings Werefkin tended to carefully structure planes and lines in curving, flowing forms. She avoided anything sharp-edged, both in form and content, so as to imbue her often narrative pictures with symbolic, universal meaning.

In their coloring it is obvious that Werefkin now deliberately employed not only primary and complementary colors as well as the colors black and white—previously rejected as "non-colors"—but also dissonant warm-cool color contrasts and blended colors (7, 9–11). She occasionally rendered her pictures in either blue tones, as in the paintings *The Dancer Sakharoff* (12) and *Im Café* (*In the Café*, 13), or red ones, as in *Tragische Stimmung* (*Tragic Mood*, 14). She could thereby underscore the special aura of the expressive dancer, the disconsolate mood of the café patrons, or a couple's—autobiographical—fatal relationship.[29]

II *Devotions*, ca. 1909, mixed media on cardboard, private collection

Werefkin drew inspiration not only from actual observation; earlier experiences, real or in dreams, also found their way into her compositions. She realized a picture idea already spoken of in France in 1903, with colors greatly deviating from nature, in the powerful painting *Der rote Baum* (*The Red Tree*, 15). A tall mountain furrowed in blue and white thrusts steeply skyward, dominating the background. The form and color of the tree incorporate Christian symbolism: the Holy Trinity and faith, love, and hope. The red of the tree's crown symbolizes love. Just as the tree motif had been anticipated seven years before, back in 1904 she had seen a group of schoolgirls in Reichertshausen that she would picture three years later in her remarkable painting *Herbst (Schule)* (*Autumn [School]*, 16): "A group of girls from a girls' school is walking down a road, the smaller ones in front and the older ones in back. White stockings, black dresses, yellow straw hats. It is as though a black reptile with a yellow back were winding past the gray houses on white legs."[30] This figural "reptile" moves along a road edged by fields and framed by bare trees against the background of a blue-black mountain and the radiant orange of an evening sky. With its lush, richly contrasting colors, this balanced composition of verticals,

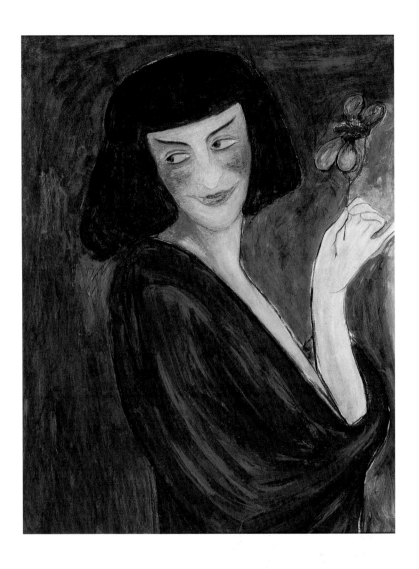

12 *The Dancer Sakharoff*, 1909, tempera on cardboard,
Fondazione Marianne Werefkin,
Museo Comunale d'Arte Moderna, Ascona

horizontals, and diagonals exaggerates the intense colors of the foothills of the Alps.

Another memory from 1904 in Reichertshausen was an experience of a religious nature: "Evening came. The sad song of Norma blended with the melancholy of the waning evening. Faint sound of bells. A priest is on his way to bring the viaticum to a submissive parting soul."[31] That memory, apparently still strong years later, found its way into the painting *Corpus Christi* (17). As in any number of other pictures, Werefkin's deep religiosity is clearly in evidence. In this and many other works the baroness—as before in Russia—processed subjects and figures from everyday life. In that earlier period she had concentrated exclusively on realistic portraits of specific representatives of the Russian lower classes. Now she pictured people immersed in their daily urban or rural routines, representing them mainly as types rather than individuals.

In addition to flat, colorful compositions and stylized elements ultimately derived from the Japanese tradition and seen in such works as *Sonntagnachmittag* (*Sunday Afternoon*, 18), *Im Café* (*In the Café*, 13), and

13 *In the Café*, 1909, tempera on cardboard,
Fondazione Marianne Werefkin, Museo Comunale d'Arte Moderna, Ascona

14 *Tragic Mood*, 1910, tempera on cardboard,
Fondazione Marianne Werefkin, Museo Comunale d'Arte Moderna, Ascona

Tragische Stimmung (*Tragic Mood*, 14), Werefkin incorporated features uniquely her own. Already in 1904 she had hit upon a striking stylistic element, that of repetition. In 1907 she again and again pictured rows of identical people, houses, beer garden motifs, or landscape elements of increasing or decreasing size, scenes she had an opportunity to observe first-hand both in Murnau and in the countryside—religious processions, costume parades, washing hung out to dry, rows of large haystacks in the landscape ("threshing" on Murnau Moor), or groups of trees. Repetition gave her a chance to structure her compositions in verticals and exciting diagonals, as impressively seen in *Herbst (Schule)* (*Autumn [School]*, 16) or *Die schwarzen Frauen* (*Women in Black*, 19). Trees and roadways are repeatedly used to structure cityscapes or landscape spaces and lend them a distinct flatness. The motif of single or multiple mountains was also among her favored pictorial elements, their skyward thrust suggestive of invincibility and the infinite. The effect is occasionally heightened by her unusually tall formats.

First deliberations about forming an association of like-minded artist friends took place in Werefkin's salon in December 1908. It was apparently her idea. As Helmuth Macke put it, Werefkin was the "soul of the entire undertaking." In addition to Kandinsky, Münter, Werefkin, and Jawlensky, the first members of the Munich New Artists' Association, founded in 1909, were Adolf Erbslöh, Alexander Kanoldt, Alfred Kubin, Oskar Wittenstein, and for a time Paul Baum, Vladimir von Bechtejeff, Erma Bossi, Karl Hofer, Charles Palmié, the sculptor Moissey Kogan, and the painter and dancer Alexander Sakharoff. It was later joined by Pierre Girieud, Henri Le Fauconnier, Franz Marc, August and Helmuth Macke, Otto Fischer, and Heinrich Campendonk as well. Kandinsky served as its first chairman, though Jawlensky had expected to. In the foreword of the association's first circular, the formulation of which is thought to have been largely Werefkin's responsibility, it proclaimed its common goals: "We are proceeding from the idea that the artist, aside from impressions he receives from the outside world, from nature, continually stores up experiences in his inner world; and the search for artistic forms with which to express his interpretations of all these interconnected experiences—for forms that must be freed from everything incidental so as to forcefully express only what is essential."

It was not until year's end that the new association was able to present itself to the public with a first exhibition at Munich's Galerie Thannhauser. Werefkin was represented with six paintings: *Waschfrauen* (*Washerwomen*, 20), *Kruzifix* (*Crucifix*, 21), *Schuhplattler* (*Bavarian Dancers*), *Sturm* (*Storm*), *Im Gebirge* (*In the Mountains*), and *Freilicht* (*Open Air*). Reactions to the exhibition, which then traveled to seven other German cities and to Brno, were extremely dismissive, even vicious. Its second exhibition, in September 1910, included artist colleagues from the French and Russian avant-garde, among them Georges Braque, Pablo Picasso, André Derain, Henri Le Fauconnier, Georges Rouault, David and Vladimir Burliuk, and Vladimir von Bechtejeff. This time Werefkin showed the works *In die Nacht hinein ...* (*Into the Night ...*), *Fleischbänke* (*Meat Stands*), *Sonnenuntergang* (*Sunset*), *Dunkler Hof* (*Dark Courtyard*), *Herbst (Schule)* (*Autumn [School]*, 16), and *Am Brunnen* (*At the Well*). The third show in late 1911 included her pictures *Dame am Strand* (*Lady on the Shore*), *Porträt*

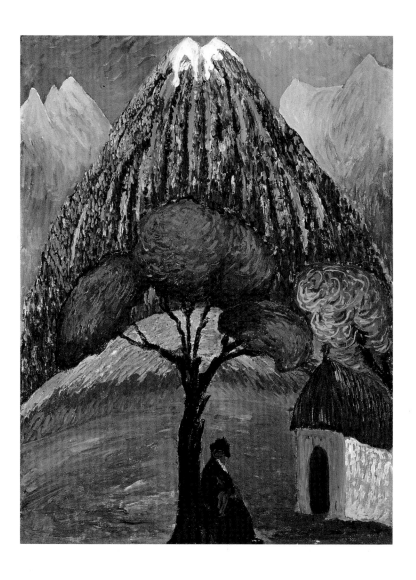

15 *The Red Tree*, 1910, tempera on cardboard,
Fondazione Marianne Werefkin,
Museo Comunale d'Arte Moderna, Ascona

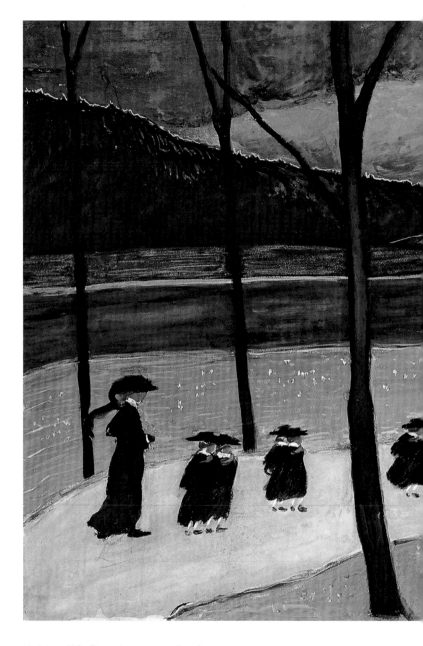

16 *Autumn (School)*, 1907, tempera on cardboard,
Fondazione Marianne Werefkin, Museo Comunale d'Arte Moderna, Ascona

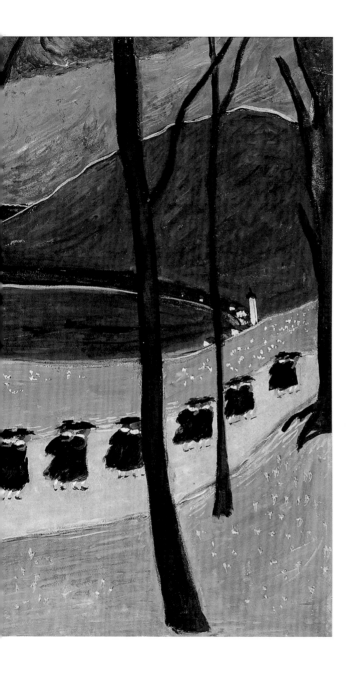

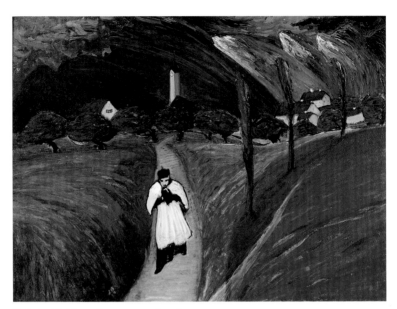

17 *Corpus Christi*, 1911, tempera on cardboard,
Fondazione Marianne Werefkin,
Museo Comunale d'Arte Moderna, Ascona

(*Portrait*), *Styx*, *Tourbillon rose* (*Pink Tourbillon*), *Segelboot* (*Sailboat*), *Abendfest* (*Soiree*), *Blaue Eimer* (*Blue Pail*), and *Kirchgang* (*Churchgoing*). Whereas these years were a fertile period for Werefkin artistically, she was not spared ongoing problems in her private life. In December 1909 her domestic conflict escalated to the point that Werefkin escaped to Kaunas, in Lithuania, where she stayed, in poor health, until April 1910. In late 1909 the character of her pictures changed under the impression of her observations in Lithuania. In its motifs and coloring her work takes on greater visionary power and meaning. Social issues, human hardship, and labor, loneliness, and night scenes predominate. Both the people's suffering and the region's picturesque beauty overwhelmed her and forced her to paint. She wrote to Jawlensky: "The picturesqueness here nearly drives a person mad. A beauty—unbelievable. On the Memel there's floating ice, and crows hunker on it as though frozen. On the opposite bank stand old houses, and here Jewish rowhouses, small cottages in pink, blue, tall churches, derelict blood-red buildings, houses of wood and brick ... and everywhere appall-

ing, appalling people. Awareness of the omnipresent suffering won't let go of me, and much more clearly than ever before I realize that all my art draws on my Russian soul; it is what understands what life means in Russian—a synonym for horror."[32] She captured these compelling impressions in pictures like *Der Krämer* (*The Grocer*, 22) and *Heimkehr* (*Going Home*, 23).

In her paintings from this period Werefkin was not concerned with portraits of specific individuals. Instead, she pictured faceless figures in their typical roles as farmers, shepherds, laborers, and priests in the town or country surroundings that defined them. Unlike the figures in her sketches, those in her paintings appear intentionally awkward, naive, anonymous, even apparitional, as in *Schlittschuhläufer* (*Ice Skaters*, 24), often intensified by repetition and groupings. She again turned her attention to the life of simple people, but now on a different, more general level. She presents them as small figures in relation to dominating landscapes. With their narrative features and symbolic imagery and coloring, these landscapes go beyond what she actually saw. The outside world thus

18 *Sunday Afternoon*, 1908, tempera on cardboard, Fondazione Marianne Werefkin, Museo Comunale d'Arte Moderna, Ascona

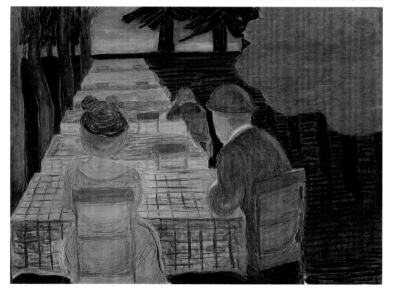

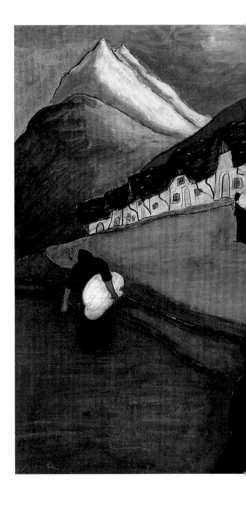

19 *Women in Black*, ca. 1910,
gouache on cardboard,
Sprengel Museum Hannover

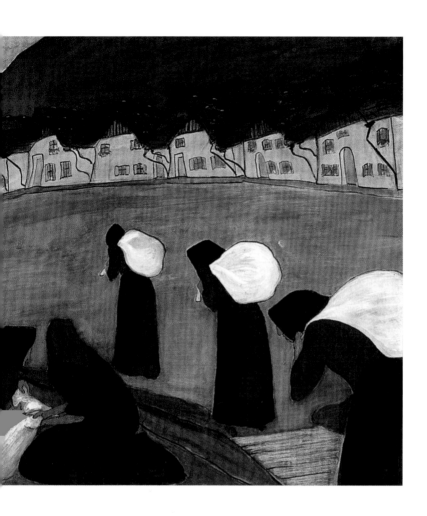

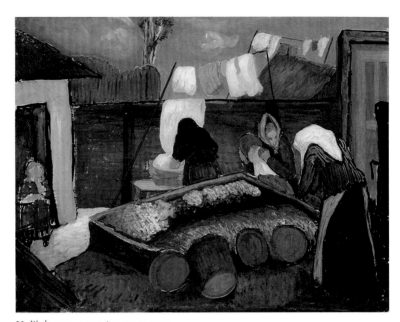

20 *Washerwomen*, 1909, tempera on paper,
mounted on cardboard,
Städtische Galerie im Lenbachhaus und Kunstbau, Munich

exposes an inner one, an intangible, invisible realm of emotion. In subject matter and imagery she addresses such emotion again and again: "Each tree, each house has its own soul, and over everything lies a profound feeling that perhaps only a Russian soul can comprehend."[33]

21 *Crucifix*, 1909,
tempera on cardboard,
private collection

By the autumn of 1910 there was already dissension within the New Artists' Association, mainly sparked by the direction in Kandinsky's work. It finally culminated in the rejection of Kandinsky's painting *Komposition V* from the association's third exhibition. Kandinsky, Münter, Marc, and Kubin resigned from the group on December 2, to be followed only a year later by Werefkin and Jawlensky. The breakaway group promptly opened a show in parallel with the Munich New Artists' Association's third exhibition at Munich's Galerie Thannhauser on December 18, 1911, the *Erste Ausstellung der Redaktion des "Blauen Reiter"* (First Exhibition by the Editorial Board of the *Blue Rider*). This editorial board, made up of Kandinsky and Marc, supported by Gabriele Münter, Maria Marc, the cousins August and Helmuth Macke, and Heinrich Campendonk, had formed during the previous summer, after Kandinsky had proposed his long-considered idea of publishing a manifesto outlining their principles and goals. In texts and pictures they wished to convey the idea that the prevailing materialistic and positivistic thinking could be overcome and the desired spiritual

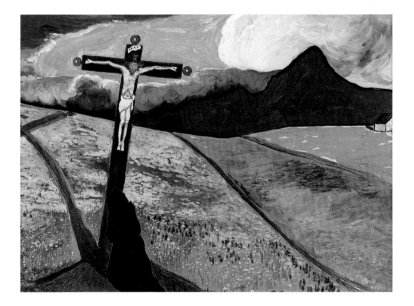

renewal achieved through a synthesis of the various arts—painting, music, and theater—in a kind of healing process. They formulated these ideas in the almanac *Der Blaue Reiter*, with an image of Saint George on the title page. It was published in May 1912 by Reinhard Piper in Munich and would become one of the most important programmatic texts on art in the twentieth century. Werefkin and Jawlensky were not involved in the project, but their allegiance to the still existing Munich New Artists' Association ended in 1912 in a quarrel over Otto Fischer's negative stance toward *Der Blaue Reiter*. They promptly left the association to join their Blue Rider friends. Despite her ongoing domestic problems, Werefkin continued to work without interruption, took part in numerous exhibitions, and enjoyed public recognition. In late 1913 there had been another crisis, one that led her to turn her back on Munich and return to Lithuania, possibly with the intention of a final separation from Jawlensky. She returned to Munich on August 1, 1914, only shortly before the outbreak of the First World War. She had only a few days before she left Germany—like Kandinsky and

22 *The Grocer*, ca. 1909, tempera on cardboard,
Bohusläns Museum, Uddevalle, Sweden

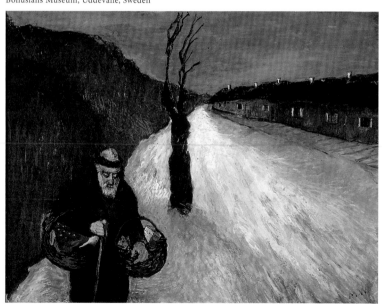

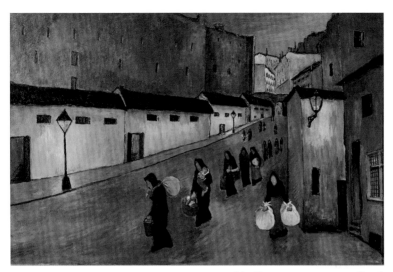

23 *Going Home*, 1909, tempera on cardboard,
Fondazione Marianne Werefkin,
Museo Comunale d'Arte Moderna, Ascona

Münter—leaving all her household possessions and collection of pictures behind in the Munich apartment. With Jawlensky, Helene Nesnakomoff, and their son, Andreas, she moved to Switzerland.

ST. PREX

In safety but in crowded and financially greatly reduced circumstances, they spent the next three years in seclusion in St. Prex, on Lake Geneva. This refuge had been arranged for them by their Russian friends the Khrushchev family. Despite the remote location, they tried as best they could to maintain contact with now far-flung friends from their Munich days. They met with Alexander Sakharoff and Clotilde von Derp, who had

following double page:
24 *Ice Skaters*, ca. 1911, tempera on cardboard,
private collection, Switzerland

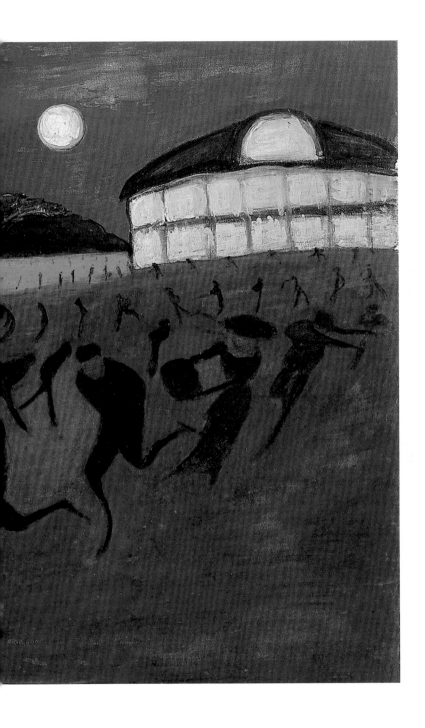

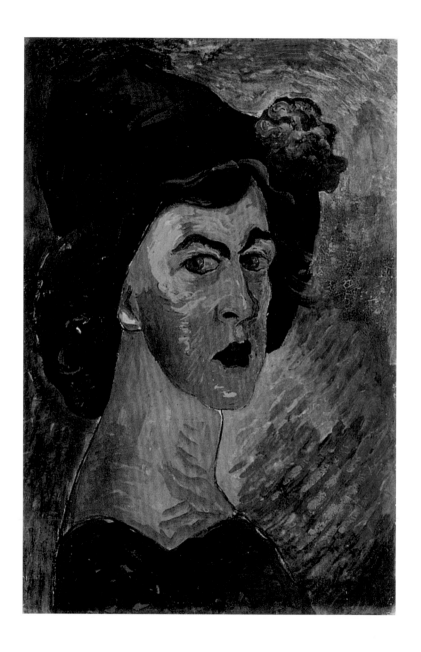

25 *Self-Portrait*, 1910, tempera on paper, mounted on cardboard,
Städtische Galerie im Lenbachhaus und Kunstbau, Munich

settled in nearby Lausanne, and the composer Igor Stravinsky, who was living in Morges. They saw Diaghilev again, and helped to get his most important dancer, Vaslav Nijinsky, released from internment in Hungary and admitted into Switzerland. They also remained in touch with the Swiss artist Cuno Amiet, who had previously belonged to the circle of painters in Pont-Aven and Die Brücke (The Bridge). Until 1917 they enjoyed close ties with the painter Ferdinand Hodler. Looking back, Werefkin felt that he and a few other connoisseurs of her painting were her most ardent admirers: "The list of my true admirers isn't long, but it reads: Repin, Hodler, Klee, the patron [?] Chudi [Tschudi] the museum director."[34] Lily and Paul Klee were particularly concerned about the lives of their friends, and helped in every way they could. During the émigrés' unexpectedly long absence, they tended to Werefkin's Munich apartment, which became frighteningly derelict, and dealt with their Munich affairs, though Werefkin was hardly in a position any longer to reward them for their efforts. As a result of Russia's October Revolution in 1917 she had lost her czarist pension. Regardless of their awkward situation, Werefkin continued her artistic efforts, and during this period, in a remarkable surge of creativity, produced some thirty paintings. For them she chose views of St. Prex and her immediate surroundings, for example in close-up motifs like *Hauseingang* (*Front Door*, 26) and *Kirche von St. Prex* (*St. Prex Church*, 1). Other paintings like *Schneewirbel* (*Snow Swirl*, 27) and *Nuit fantastique* (28) continued themes that had essentially occupied her in her Munich years and were in part influenced by her emotionally oppressive situation.

ZURICH

In October 1917 Werefkin and Jawlensky moved to Zurich. During the First World War the city had become a refuge for countless émigrés, among them a large number of artists. It is thus understandable that the two should have been drawn there so as to be able to take part in the city's vibrant art scene.

Despite the shocking war reports and the multitude of emigrants thrown together there, Zurich managed to foster a number of new intellectual and artistic trends. Remarkably, this creativity coalesced into the Dada movement, founded in 1916, one in which Werefkin and Jawlensky were not

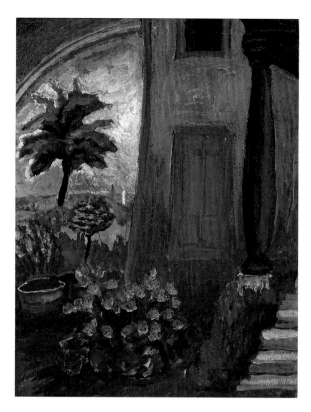

26 *Untitled*
(St. Prex, Front
Door, Garden with
Rainbow), 1916,
tempera on
cardboard, private
collection,
Switzerland

directly involved. Werefkin continued to process social concerns in pictures like *Le Peine*, *Le Chiffonnier*, and *Feux sacrés*,[35] while Jawlensky further developed his *Variationen über ein landschaftliches Thema* (*Variations on a Landscape Theme*) begun back in St. Prex in a new series of *Mystischer Köpfe* (*Mystical Heads*). Here he was influenced by their new acquaintance Emmy Scheyer, a young artist from Braunschweig. Instead of continuing to work as a painter herself, Scheyer decided to function as his art agent—not Werefkin's.[36]

27 *Snow Swirl*, 1915,
tempera on cardboard,
Lentos Kunstmuseum Linz

ASCONA

Their stay in Zurich, undertaken with such high hopes, ended after only
six months in April 1918, when Jawlensky contracted a life-threatening
influenza and was advised to seek a more temperate climate. So Werefkin,
Jawlensky, Helene, and Andreas moved to Ascona, on Lake Maggiore. The
spot was not chosen for health reasons alone; the Ticino, and especially
Ascona, had long been a magnet for artists and intellectuals. It was there
in 1900, as part of the widespread reform movement, that a utopian colony
was established above Ascona on Monte Verità. Its alternative lifestyle
would not prevail over time, but any number of intellectuals, artists, and
writers continued to be drawn to it well into the 1910s.

The pair's domestic situation was repeatedly fraught and nerve-wracking,

and now there were quarrels about Jawlensky's determination to marry Helene Nesnakomoff. This finally forced a separation in 1921. In May Jawlensky traveled to Wiesbaden for an exhibition of his pictures and promptly settled there. Yet he hesitated for another year before fetching Helene Nesnakomoff and his son to Wiesbaden and marrying the mother of his son.[37] For Werefkin a chapter filled with years of difficult personal turmoil had closed for good.

"FROM NOW ON A NEW LIFE BEGINS FOR ME"[38]

The baroness carried on with what was most important to her: painting. In many of her pictures she recalled the period before 1914, now placing her subject matter in the mountain and lake region of Ticino, impressively exaggerating the height and close confines of its landscape motifs (29). She pictured the hard lives of factory workers or Lake Maggiore's fishermen exposed to the forces of nature. Scenes of storms and dangers have a gloomy, menacing quality thanks to a dark palette accented with flashing contrasts (30, 31). In these years she was again not primarily concerned with accurate portraits. She relied on exaggeration as a way to depict the lives of ordinary people filled with hardship, fear, and danger, and to suggest their essential humanity.

She developed other artistic activities in addition to her painting. For example, in 1922 she founded Ascona's Museo Comunale together with the painter Ernst Kempter. For a start, she donated four of her own paintings, and arranged for numerous bequests of pictures from other Ascona artists. Two years later she founded the artists' group Der Große Bär (The Great Bear) together with the painters Walter Helbig, Ernst Frick, Albert Kohler, Gordon McCouch, Otto Niemeyer-Holstein, and Otto van Rees. With this active circle of artists, soon joined by Richard Seewald and Arthur Segal, the baroness was not only a major presence in Ascona, she also occasionally participated—alone or with the others—in exhibitions in Switzerland and Germany, the important first Bauhaus exhibition in 1923,[39] for example, and a Great Bear show at the Kunsthalle Bern in 1925.

Through her painting, in 1928 a personal connection developed with the well-to-do Zurich insurance executive Diego Hagmann and his wife, Carmen. The couple began to regularly buy her pictures, and would

28 *Nuit fantastique*, 1917, tempera on cardboard,
private collection

29 *The Crossroad II*, 1921, tempera on cardboard,
Fondazione Marianne Werefkin,
Museo Comunale d'Arte Moderna, Ascona

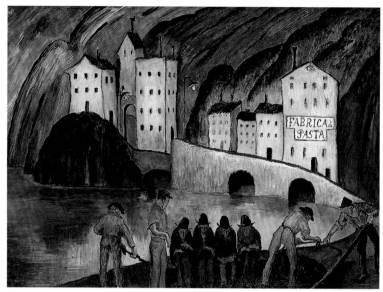

30 *Vivants et morts*, ca. 1924, tempera on cardboard,
Fondazione Marianne Werefkin,
Museo Comunale d'Arte Moderna, Ascona

occasionally discreetly take care of her unpaid bills. With such generous
gestures they eased the financial distress of the now nearly seventy-year-old
woman living in straitened circumstances.[40]

The German writer Hans Sahl visited Ascona in the late 1920s and put up
at an albergo. While there he met Marianne von Werefkin and was im-
pressed: "At one of the tables sat an old woman who had apparently been
watching me for some time. She was wearing a shawl wound around her
head like a turban, which gave her, together with a threadbare evening
cloak hanging from her shoulders, the appearance of a fortune-teller or
some other light-shy nocturnal figure who had mistakenly strayed into the
bright sunlight of a Ticino morning. 'Might I sit with you?' she asked
across the tables. I nodded. She stood up and joined me. 'I am Baroness
von Werefkin,' she said. 'I was acquainted with the great painters of my
century, Kandinsky, Jawlensky, take note of the names, young man. They
dared what was new, the mystery, the incomprehensibility of nature. Art
has to become mysterious again, the great Kandinsky said to me in Munich,
as impenetrable as the language of birds, yet as colorful as their plumage

31 *The Pit*, ca. 1926, tempera on cardboard,
Fondazione Marianne Werefkin,
Museo Comunale d'Arte Moderna, Ascona

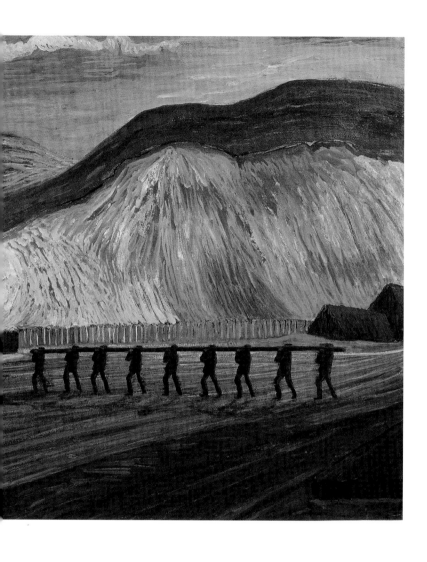

and as mysterious as their singing. I live in a tower above the Saleggion, and the pictures by my friends speak to me in colors, forms, signs. The great Jawlensky spoke with fishes and flowers; I speak with God when I paint, or with myself. Come to my tower. I'll show you pictures the like of which you've never seen—blue horses, square cows, and colors, lines, circles.'"[41]

To the end people admired the painter's spirited vitality. Self-confident, creative, and protective of her personal freedom, all her life Marianne von Werefkin pursued her own goals, among them her profound devotion to art. She produced a high-quality, innovative body of work, and contributed importantly to the development of modern art at the beginning of the twentieth century. Despite her extremely modest circumstances, she continued her art, which she understood as a service to mankind, up until her death in 1938, and professed: "one fine day one sees the whole world with different eyes—with truly seeing eyes … . When … one sees oneself not as the navel of the world, but as one speck of dust among myriad specks of dust."[42]

BRIGITTE SALMEN *served as director of the Schlossmuseum Murnau from 1989 to 2011. There she initiated numerous special exhibitions, including shows of Vasily Kandinsky, Franz Marc, Gabriele Münter, Marianne von Werefkin, and Hilla von Rebay. She has published numerous articles and books, among them a monograph on Marianne von Werefkin (2012) and catalogues raisonnées of the paintings of Sonja Besch (2013) and Adolf Erbslöh (2016).*

1 Marianne von Werefkin, *Briefe an einen Unbekannten 1901–1905*, ed. Clemens Weiler, Cologne 1960, p. 18. This quote has been abbreviated: "Die Kunst … ist der Himmel über mir und die Seele in meiner Brust."

2 The "von" came to be added only in her years in Germany.

3 According to Western reckoning.

4 Werefkin to Diego Hagmann, mid-October 1932; quoted from Bernd Fäthke, *Marianne Werefkin* (Munich: Hirmer, 2001), 39.

5 Bernd Fäthke, *Jawlensky und seine Weggefährten in neuem Licht* (Munich: Hirmer, 2004), 23.

6 Brigitte Roßbeck, *Marianne Werefkin: Die Russin aus dem Kreis des Blauen Reiters* (Munich: btb, 2010), 43.

7 Ilja Repin to Vladimir N. Werefkin, 17 October 1893. Brigitte Roßbeck graciously placed at my disposal Repin's *Ausgewählte Briefe*, trans. Jiri Ort, Seeshaupt (Moscow, 1969).

8 Fäthke, *Marianne Werefkin*, 26–27 (see note 4).

9 Ibid., 41.

10 Nesnakomoff was at this point presumably ten years old; see Roßbeck, *Marianne Werefkin*, 53 (see note 6).

11 Ibid., 51–52.

12 Marianne von Werefkin, *Briefe an einen Unbekannten*, booklet 1, 1902, 194–95, quoted from Annekathrin Merges-Knoth, "Marianne Werefkins russische Wurzeln" (diss., Universität Trier, 1996), 50. Translation by Gerlinde Off, Penzberg. I am grateful to Brigitte Roßbeck for placing this translation at my disposal.

13 See Roßbeck, *Marianne Werefkin*, 52 (see note 6).

14 Fäthke, *Marianne Werefkin*, 53–54 (see note 4).

15 See Katarina Ambrozić, *Wege zur Moderne und die Ažbe-Schule in München*, exh. cat. Wiesbaden (Recklinghausen: Aurel Bongers, 1988).

16 Quoted from Fäthke, *Marianne Werefkin*, 53 (see note 4).

17 Gustav Pauli, *Erinnerungen aus sieben Jahrzehnten* (Tübingen: Wunderlich, 1936), 264–65.

18 Quoted from Jelena Hahl-Koch, *Marianne Werefkin und der russische Symbolismus: Studien zur Ästhetik und Kunsttheorie*, Slavistische Beiträge 24 (Frankfurt: Peter Lang, 1967), 94.

19 Formulated, for example, in 1901 in the first booklet of her *Briefe an einen Unbekannten*; see Weiler, *Briefe* (see note 1).

20 He began his first formulations in 1904, then further in 1908, completing the main text between 1909 and 1911. See Reinhard Zimmermann, *Die Kunsttheorie von Wassily Kandinsky* (Berlin: Mann, 2001), 2:19.

21 Weiler, *Briefe*, 43 (see note 1).

22 Fäthke, *Marianne Werefkin*, 66 (see note 4).

23 Quoted from Roßbeck, *Marianne Werefkin*, 89 (see note 6).

24 Ibid., 88.

25 Quoted from Weiler, *Briefe*, 43 (see note 1).

26 Fäthke, *Jawlensky und seine Weggefährten*, 81 and 88 (see note 5).

27 Quoted from Weiler, *Briefe*, 27 (see note 1).

28 Bernd Fäthke, "Von Werefkins und Jawlenskys Faible für die japanische Kunst," in: *"... diese zärtlichen, geistvollen Phantasien ..." Die Maler des "Blauen Reiter" und Japan*, ed. Brigitte Salmen, exh. cat. Schlossmuseum Murnau (Murnau: Schlossmuseum Murnau, 2011), 103–32.

29 For Werefkin's tone-in-tone painting, see Fäthke, *Marianne Werefkin*, 86ff (see note 4).

30 Quoted from Weiler, *Briefe*, 40 (see note 1).

31 Ibid., 41.

32 Werefkin to Jawlensky on 17 December 1909, from Kaunas; quoted from Laima Laučkaitė, *Ekspresionizmo raitelė Mariana Veriovkina* (Vilnius: Kultūros, 2007), 232ff.

33 Quoted from Hahl-Koch, *Marianne Werefkin und der russische Symbolismus*, 101 (see note 18).

34 Quoted from Nicole Brögmann, ed., *Marianne von Werefkin: Oeuvres peintes 1907–1936*, exh. cat. Fondation Neumann (Gingins: Fondation Neumann, 1996), 78n75.

35 See Fäthke, *Marianne Werefkin*, illustrations 215–17 (see note 4).

36 See Volker Rattemeyer, *"Jawlensky: Meine liebe Galka!,"* exh. cat. Museum Wiesbaden (Wiesbaden: Museum Wiesbaden, 2004), 169ff.

37 For the entire episode, see Fäthke, *Marianne Werefkin*, 198–200 (see note 4).

38 Werefkin in her diary on May 12, 1922. The quote was graciously provided me by Brigitte Roßbeck.

39 Roßbeck, *Marianne Werefkin*, 211 (see note 6).

40 See Fäthke, *Marianne Werefkin*, 235–39 (see note 4).

41 Hans Sahl, *Memoiren eines Moralisten, Das Exil im Exil* (Munich: Luchterhand, 2008), 159–62 and 164. I am truly grateful to Melchior Schedler for suggesting this to me.

42 Quoted from Fäthke, *Marianne Werefkin*, 217 (see note 4).

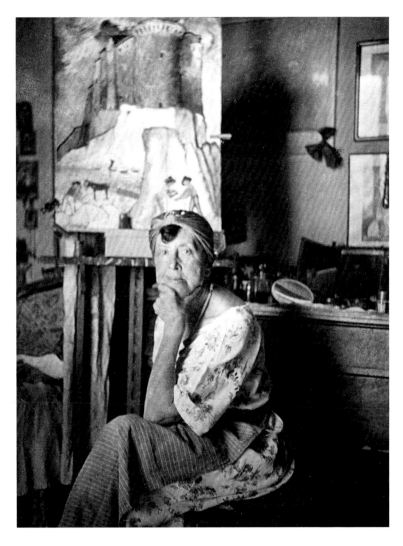

32 Marianne von Werefkin with her painting
Castle on the Mediterranean, ca. 1927

BIOGRAPHY

Marianne von Werefkin
1860–1938

1860 On September 11 Marianne Werefkin—Marianne Vladimirovna Werjovkina—is born in the Russian provincial town of Tula, where her father, Vladimir Nikolaevich, is stationed as commander. Her mother, Yelizaveta, née Daragan, is a well-regarded portrait and icon painter and, like her husband, from an aristocratic Russian family.

1862–72 Her younger brother Peter Vladimirovich is born in 1862. In the following year her father is stationed to Vitebsk as governor general, and in 1868 he is transferred to Vilnius, the capital of Lithuania, as a lieutenant general. Previously taught by governesses, there Marianne attends St. Mary's Institute, a finishing school for a select group of pupils from which she graduates with great success. In 1872 a second brother, Vsevolod, is born.

1879–80 The family moves to Polish Lublin, at this time the Russian provincial capital, where Marianne's father has been posted. Czar Alexander II presents her father with the estate Blagodat, near Kaunas, in Lithuania, to which Marianne frequently retreats in order to paint in the studio built for her. She takes painting instruction from various teachers, among them P. Heinemann in Warsaw. Around 1880 she meets Ilja Repin in Moscow, the most famous proponent of Russian Realist painting.

1883–84 In Moscow Werefkin attends the School of Painting, Sculpture, and Architecture, studying painting under Illarion Mikhailovich Pryanishnikov. In addition, she reads classical literature and engages with fundamental issues in philosophy and art theory and becomes informed about Western European avant-garde art. She creates her first paintings, in which picture contrasts between rich and poor.

1885–86 Her mother, Yelizaveta, dies. Marianne follows her father to St. Petersburg, where he is appointed commandant of the Peter-and-Paul-Fortress. Since the St. Petersburg Academy does not admit women, for the following ten years she takes private painting lessons under Repin. In St. Petersburg she leads a busy social life, regularly entertaining any number of artists. In the mid-1880s she becomes acquainted with the physician Vasily Vladimirovich Lesin, with whom she is closely linked for seven years.

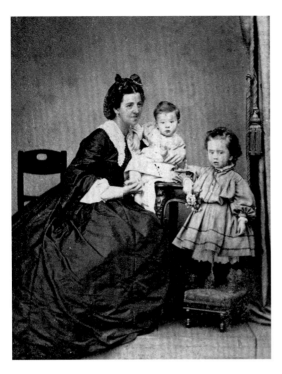

33 Yelizaveta Petrovna Werefkina, née Daragan, with her son Peter in her arms and daughter, Marianne, ca. 1863

34 Marianne Werefkin's studio at Blagodat, near Kaunas, Lithuania, 1879

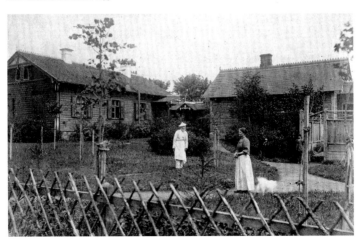

1888 In November Werefkin shoots herself in her right hand while on a hunting outing at Blagodat. She is forced to refrain from painting for a year, and from this time on she employs small devices to relieve the continuing stiffening of her hand.

1890 Marianne Werefkin is represented with at least four pictures at the first exhibition of the St. Petersburg artists' association. Beginning in the 1890s she focuses increasingly on the characteristics of painting techniques and the emotional effects of colors and their combinations.

1892 Through Ilja Repin Werefkin is introduced in the spring to the officer Alexei Jawlensky, who in addition to his military service is studying at the St. Petersburg Art Academy. After a short time she decides to live with him.

1895 The relationship between the two artists is filled with conflict. Jawlensky feels that Werefkin is too dominating. In addition, he falls in love with Marianne's young chambermaid, Helene Nesnakomoff. Werefkin finds herself in an artistic crisis, and determines to abandon painting in order to promote Alexei Jawlensky's talent.

1896 In January Werefkin's father dies. At the urging of Jawlensky, who feels he can develop further artistically through study abroad, they move with Helene to Munich in October. Beforehand, Werefkin has used her influence to get Jawlensky released from military service.

1897 In Werefkin's Giselastrasse apartment in Munich a salon develops that attracts artists, including many from the Russian avant-garde, writers, dancers, actors, and intellectuals. Werefkin furnishes a painting studio for Jawlensky in her rooms. The Brotherhood of St. Luke is formed around Werefkin, with Jawlensky, Anton Ažbe, Igor Grabar, Dmitry Kardovsky, Hans Reinhold Lichtenberger, and others. In April Werefkin travels with several of them to Venice to visit an international art exhibition.

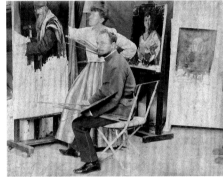

35 Marianne Werefkin, 1889

36 Marianne Werefkin with
Alexei Jawlensky in front of the easel
in her studio at Blagodat, 1893

37 Marianne Werefkin's atelier in the Peter and Paul Fortress, St. Petersburg,
or a room in the Art Academy, with paintings presented by various painters, 1893/96

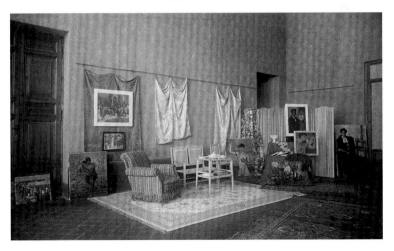

1898–99 In March Werefkin and Jawlensky set out for six months in Russia, where apparently the purchase of a larger property is discussed but does not take place. From March to June 1899 Werefkin travels alone to Latvia, Lithuania, and St. Petersburg, where she meets with Repin once again.

1900–1902 Werefkin begins to doubt whether a further life with Jawlensky is possible, for he even rejects her influence on his art. In November 1901 she again travels to Lithuania, and immediately after her return she is forced to go back north again, this time together with Jawlensky and the underage Helene, who is pregnant with his child. Until November 1902 they stay at Anspacki Palace near Vilnius; Jawlensky's son, Andreas, is born there, and back in Munich he is introduced as Jawlensky's nephew. During their absence Vasily Kandinsky, one of their Munich circle of friends, takes care of Werefkin's apartment and uses Jawlensky's atelier.

1903 From August to October Werefkin travels with her friend Alexander von Salzmann to Normandy and Paris. Liberated from her troubles at home, she is open to new impressions and artistic insights.

1904–5 After Jawlensky and Werefkin spend three months in Reichertshausen an der Ilm in the summer of 1904, in 1905 they consider living outside Munich permanently and settling in the countryside; one possible location is Murnau, south of Munich. But the purchase of a property on the Staffelsee falls through.

1906 In February, in a period of domestic calm, Werefkin abandons her *Lettres à un Inconnu*, begun in 1901. In its three booklets she had recorded through the years her thoughts, feelings, frustrations, and ideas on art (see p. 72). In the spring Werefkin travels again to France, accompanied by Jawlensky, Helene, and Andreas, first to Brittany, then to Paris, and in October to Provence and the Mediterranean coast. Late in the year they head for Geneva to visit the Swiss artist Ferdinand Hodler, whom Werefkin will name in 1932, in retrospect, as one of her greatest admirers, along with Repin, Klee, and Tschudi, director of the Staatliche Galerien in Munich. At the end of the year Werefkin determines to paint again.

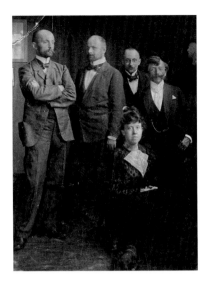

38 The painters Dmitry
Kardovsky, Alexei Jawlensky,
Igor Grabar, Anton Ažbe,
and Marianne von Werefkin,
Munich, 1897

39 Marianne von Werefkin,
Alexei Jawlensky, and four others
at Anspacki Palace near Vilnius,
Lithuania, 1902

40 Werefkin and Jawlensky with two
young ladies in their salon in Munich,
Giselastrasse 23, ca. 1905

1907 Werefkin and Jawlensky travel to Wasserburg, where she produces bright, finely hatched colored pencil and pastel sketches with landscape motifs. During a first extended stay in Murnau Werefkin develops a new painting style.

1908 In the summer Werefkin and Jawlensky spend a few decisive and inspiring weeks in Murnau with Kandinsky and Gabriele Münter. In December the idea of an association of like-minded painters is floated in Werefkin's salon.

1909 In January the Munich New Artists' Association is founded, and Kandinsky assumes its chairmanship in place of Jawlensky, who was first considered for the post. The first exhibition of the new association is held from December 1 to 15 at Munich's Galerie Thannhauser on Theatiner-strasse. It includes a total of 128 works by 14 of the association's members and two other painters. Werefkin is represented with 6 paintings. The exhibition is met with dismissive criticism in the press. In December Werefkin travels to Kaunas to escape her domestic conflicts, and stays there—presumably in part owing to her health—until April 1910.

1910 The Munich New Artists' Association's second exhibition is presented, again in Munich's Galerie Thannhauser, from September 1 to 14. It includes works by artist colleagues from the French and Russian avant-garde like Georges Braque, Pablo Picasso, and Vladimir von Bechtejeff.

1911 From July to September Werefkin and Jawlensky travel with Helene and Andreas to the Baltic coast, visiting Prerow, Ahrenshoop, and Zingst, where Werefkin captures her impressions in numerous sketches. In the summer the Redaktion des *Blauen Reiters* (Editorial Board of the *Blue Rider*) is formed, made up of Kandinsky, Franz and Maria Marc, August and Helmuth Macke, and Heinrich Campendonk. On December 2, after major disagreements within the Munich New Artists' Association, Kandinsky, Münter, Marc, and Kubin leave the group. At year's end Werefkin and Jawlensky visit Paris to see the newest art, and there for the first time encounter works by Henri Matisse. The third exhibition of the Munich New Artists' Association opens in the Galerie Thannhauser on December 18, at the same time as the first show of the Blue Rider.

1912 Although still members of the Munich New Artists' Association, Werefkin and Jawlensky take part in the second Blue Rider exhibition, which opens on February 12 at Munich's Hans Goltz Gallery on Brienner Strasse. The two are also represented in the traveling Blue Rider show, hosted by Herwarth Walden in Berlin at his Berlin Galerie Sturm. In May Werefkin participates in the legendary Cologne exhibition *International Art Exhibit by the Separate League of West German Art Lovers and Artists*. As a response to the rejections of works from that show, including some by Blue Rider painters, in mid-June Herwarth Walden mounts in his Berlin gallery the exhibition *Deutsche Expressionisten (Zurückgestellte Bilder des Sonderbundes Köln)* (*German Expressionists [Pictures Rejected by the Cologne Sonderbund]*), which includes works by Werefkin and Jawlensky. In October, as in the summer of the previous year, Werefkin is represented in the first collective show at the Hans Goltz Gallery. After fundamental disagreement with Otto Fischer's text in the book *Das Neue Bild*, Werefkin and Jawlensky finally drop out of the Munich New Artists' Association in December and join the Blue Rider.

1913 In February the Blue Rider circle develops the idea of an art institute, one strongly supported by Werefkin. Herwarth Walden is proposed as its director, but after he declines the plans are dropped. From September to November Werefkin is represented with three works at the *Erster Deutscher Herbstsalon* (*First German Autumn Salon*) at Walden's Galerie Sturm in Berlin. At the end of the year Werefkin again travels to Lithuania to distance herself from her oppressive domestic situation.

1914 At the *Grosse Baltische Ausstellung* (*Great Baltic Exhibition*) from May to October in Malmö, Sweden, Werefkin's work is shown for the first time abroad. In August, just before the outbreak of the First World War, she returns from Lithuania to Munich, and soon thereafter leaves Germany in direction Switzerland for good along with Jawlensky, Helene, and Andreas.

1916 The four live in modest circumstances in a two-and-a-half-room apartment in St. Prex, on Lake Geneva. Werefkin is able to keep painting after a woman friend furnishes her with a small studio. Her work is exhibited at the Kunstsaal Audretsch, in The Hague, and at Zurich's Galerie Corray, but none are sold.

1917–18 As a result of the Russian Revolution in 1917 Werefkin's pension is revoked. In October the four émigrés move to Zurich, only to have to leave again in April 1918 for Jawlensky's health. They move to Ascona on Lake Maggiore.

1919–20 In 1919 Werefkin takes part in an exhibition at Zurich's Kunstsalon Wolfsberg, and in early 1920 works of hers are shown at the Kunsthaus Zurich together with sculptures by Alexander Archipenko. She is also represented with two works at the Venice Biennale. In July Werefkin travels to Munich for a trial following a break-in at her apartment. In despair over its run-down condition she returns to Ascona.

1921 When Jawlensky fails to return from a trip to Wiesbaden, a final separation from Werefkin is effected. In the following year he will send for Helene and Andreas and marry the mother of his son. Werefkin holds herself above water financially by selling a few pictures and small drawings of Ascona views for tourist postcards. In addition, she receives a small stipend from the Swiss Red Cross. Though she had previously lived with Jawlensky, Helene, and Andreas in the Bezzola family's castello at the east end of the Piazza, she now temporarily occupies a one-and-a-half-room apartment in the home of the Perucchi family.

1922–24 Together with the painter Ernst Kempter, Werefkin establishes the Museo Comunale in Ascona and donates four of her own paintings. Thanks to her contacts with other Ascona artists, the museum is presented with a number of other works. In the summer of 1923 she is represented at the first Bauhaus exhibition in Weimar. With other artist colleagues, in 1924 she forms the artists' group Der Große Bär (The Great Bear) which will show its work in the following year at the Kunsthalle Bern.

1925–26 For several weeks Werefkin travels in Italy with her close friend the Berlin concert singer Ernst-Alfred Aye, visiting Naples, Pompeii, and Ischia. First arrived in Ascona as a tourist, Aye had helped Werefkin through the first years of her separation from Jawlensky, and become her closest long-term friend and confidant. She advises the Wuppertal banker and collector Eduard von der Heydt to buy the colony on Monte Verità in Ascona.

41 Marianne von Werefkin, Alexei Jawlensky, Gabriele Münter, and Jawlensky's son, Andreas, on Sollerstrasse in Murnau, ca. 1909

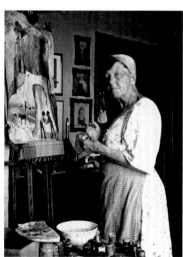

42 Marianne von Werefkin
at work on the picture
Castle on the Mediterranean, ca. 1927

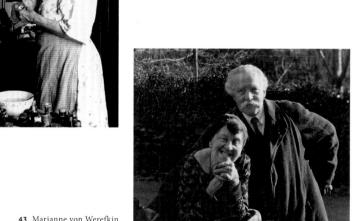

43 Marianne von Werefkin
with her brother Peter in Ascona, 1929

1927 With the Berlin writer and painter Otto Nebel, Werefkin establishes a painting school that they call Cavello rosso, but it soon closes. In this same year the Kunsthaus Zurich exhibits twenty of her paintings.

1928–37 Werefkin becomes acquainted with the well-to-do Zürich insurance executive Diego Hagmann and his wife, Carmen, and profits from their occasional purchases of paintings and financial contributions. During her time in Ascona Werefkin keeps in contact with her extensive network of old and new friends. She is sought out by numerous intellectuals and artists; among her visitors over the years are the Bonn writer Wilhelm Schmidtbonn, Else Lasker-Schüler, Helmuth Macke, Maria Marc, Gabriele Münter, her brother Peter, and the North German writer Bruno Goetz, who in 1927 had created an idealized description of Werefkin in his novel *Das göttliche Gesicht* (*The Divine Visage*).
She spends the last years of her life in the home of the Perucchi family in Ascona.

1938 Marianne von Werefkin dies on February 5, and her burial two days later is attended by a large number of mourners.

44 Marianne von Werefkin at the home
of Diego Hagmann, ca. 1930

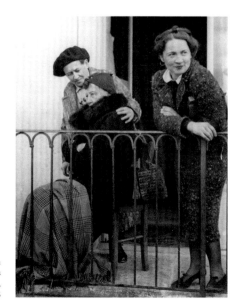

45 Marianne von Werefkin
with her caretakers
Noemi and Rosetta Perucchi,
ca. 1936

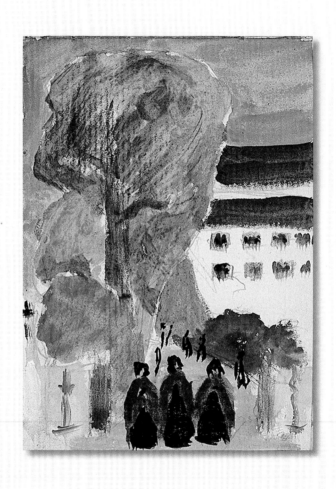

Road to the Church of St. Nikolaus with View of the Palace, ca. 1908,
Sketchbook FMW a24/43, Fondazione Marianne Werefkin, Museo
Comunale d'Arte Moderna, Ascona

ARCHIVE

Discoveries, Letters, Documents
1901–1920

In view of her difficult relationship with Alexei Jawlensky, especially after Helene Nesnakomoff had become pregnant with his child, and because of the hopelessness of her efforts to pass along her artistic convictions to him, toward the end of 1901 Marianne Werefkin began to put in writing her thoughts, feelings, frustrations, and yearnings, also her insights about art, in her Lettres à un Inconnu, *which she continued for a good five years. These were letters to herself: "You, that is to say essentially I, but a wholly different I, noble and great, a genial I, as different from the little I as the dream from reality." In these dialogues with herself she outlines common human emotions, her inner conflict between visions and reality, and engages in far-reaching deliberations on her role as an artist, as one who gives and takes, and describes her joys and her sorrows.*

The color blue, so important to the Romantics and associated with the sense of yearning, appears again and again in these entries, generally written at night, which she called her "blue stories." She spoke of "blue wings," "blue birds," "blue stars," "blue shadows," "blue dreams." She also reflected on her abstinence from painting. At times, by 1902 at the latest, she was tempted to paint again: "All the pictures I've been carrying around inside for a long time are resurfacing. Visions and colors, everything is whirling in me and around me. This morning brushes burned in my hands. Oh, what torture!" But it would be roughly four more years before she found her way back to her own painting.

Apparently a period of calm and clarity followed the years of conflicts with Jawlensky, for in February 1906 Werefkin ended her Lettres à un Inconnu: *"I have looked into my heart. I have seen calm there. I can close this little book."*

2

With their abundance of drawings and ink and color sketches, Werefkin's sketchbooks document her fresh and manifold impressions in Munich and in Murnau, beginning in 1907, that influenced the artist after she resumed painting. She described the area's motifs in bright, unmixed colors, freely and with great verve, animation, and ease, with a sure, passionate line—Murnau's typical houses and two landmark major buildings, the palace and the church, and locals on streets and squares, at folk festivals, in beer gardens, and at religious events. She sketched meadows and fields again and again, the nearby villages,

and the surrounding landscape with the silhouette of the staggered mountains of the north edge of the Alps.

These sketches and studies attest to Werefkin's attentive gaze during her stays in Murnau beginning in 1907. She became involved with the people and the setting, described them in wonderfully spontaneous individual motifs and scenes powerfully captured in line and color and reduced to the essentials. They provide a lively impression of traditional, bucolic Murnau and its landscape.

The swiftly sketched motifs focus on essential, distinctive accents. Werefkin's imagery, with its previously unsuspected, expressive coloring and concentration and dissolution of forms, is highly impressive. With it she consistently attests to the primacy of emotion in painting, as she had recognized it as early as 1901.

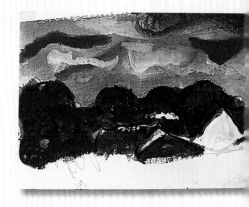

2a *Murnau from the North, with Palace and Church of St. Nikolaus,* ca. 1908, Sketchbook [ll], mixed media, private collection, Switzerland
2b *Farm Women Mowing on the Murnau Moor, in the Background the Wetterstein,* ca. 1908, Sketchbook all/14-15, Fondazione Marianne Werefkin, Museo Comunale d'Arte Moderna, Ascona

2a

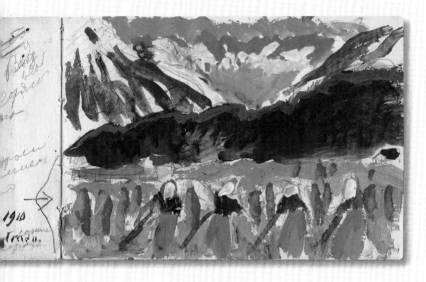

2b

Next double page:
2c *Murnau Landscape with View of the Foothills of the Alps with the Hörnle*, ca. 1908, Sketchbook FMW a19/8-9, Fondazione Marianne Werefkin, Museo Comunale d'Arte Moderna, Ascona

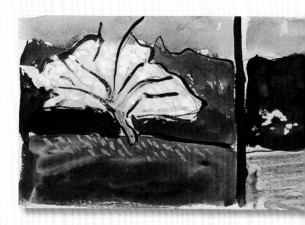

2c

3

Parting from her earlier life had left deep wounds in Werefkin. A permanent
return to her Munich apartment after the First World War proved illusory, as
it was financially impossible. In addition, the apartment was in derelict con-
dition, as Paul Klee wrote her on June 24, 1919:

"I don't wish to conceal from you the condition of your apartment. It is
virtually hopeless. One chokes in the dirt and dust. Aside from this, which
could of course be cleaned up, the hangings and upholstered furnishings
are completely moth-eaten and ruined. They are crawling with moths,
worms, and larvae … pictures and wooden furniture haven't seemingly
suffered. Your cupboards are partly damaged owing to the break-in last
year and robbed of their contents. However some things have been brought
back by the concierge thanks to the discovery of the perpetrators, who are
now serving their sentences."

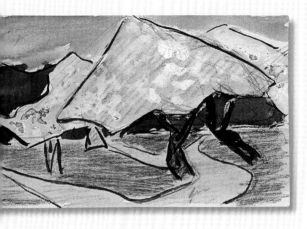

After Werefkin had visited her apartment in Munich in 1920, at the time of the break-in trial, and returned to Ascona, on July 26 she summed up in her diary:

"I have tortured my soul to death to compel it to let go of the past, I have subjugated my thoughts by limiting them to the business at hand, I have frozen my heart and forced it to forget. Seven years have passed, have fallen heavily on the events of my personal life. Everything has changed. I have discarded the debris of my home, my lifeless thoughts have given no voice to my memories. I have once more retraced all the paths of the past, I have touched everything that was—my chastened heart has not heaved a sigh. And now the year, the date, and the location always noted down on the same pages of this book, which resembles its older brothers, appears to be a bridge to what my life was and what I have commanded myself to forget. At the same time I am perfectly aware that the reality of this past life has disappeared forever; like an amputated limb whose nerves no longer register pain, for one has learned to do without it, yet that awakens fond memories because it once carried a (treasured) object."

SOURCES

PICTURE CREDITS

Photos were graciously placed at our disposal by the following museums and collections (identified by page numbers)

akg images: 47
Artothek Weilheim: 41
bpk, Sprengel Museum Hannover, Aline Herling/ Michael Herling/Benedikt Werner: 36–37
Bohusläns Museum, Uddevalla/Sweden: 40
Fondazione Marianne Werefkin, Museo Comunale d'Arte Moderna, Ascona: 8, 27, 28–35, 50–53, 70, 73–77
PSM Privatstiftung Schlossmuseum Murnau: 14 left, 56, 59, 61, 63, 67 centre below, 69
Schlossmuseum Murnau: 19
Städtische Galerie im Lenbachhaus und Kunstbau, Munich: 38, 44, 67 above

TEXT EXCERPTS HAVE BEEN DRAWN FROM THE FOLLOWING SOURCES

(see also notes, pp. 54–55)
Marianne von Werefkin, *Briefe an einen Unbekannten 1901–1905*, ed. Clemens Weiler, (Cologne: DuMont, 1960), pp. 9, 10, 17, 20, 21, 27, 30, 50: 72
Marianne von Werefkin, Diary 1920–1925, Fondazione Marianne Werefkin, Ascona, July 26, 1920: 77
Paul Klee, *Briefe an die Familie 1893–1940, Band 2: 1907–1940*, ed. Felic Klee, (Cologne: DuMont, 1979), p. 980: 76

Published by
Hirmer Verlag GmbH
Bayerstraße 57–59
80335 Munich
Germany

Cover illustration: *Self-Portrait* (detail),
ca. 1910, see p. 44
Double page 2/3: *Going Home* (detail), 1909,
see p. 41
Double page 4/5: *Snow Swirl* (detail), 1915,
see p. 47

The publication includes text exerpts taken from
Marianne Werefkin. Leben für die Kunst by
Brigitte Salmen, ed. PSM, Privatstiftung
Schlossmuseum Murnau, published 2012
by Hirmer Publishers.

www.hirmerpublishers.com

TRANSLATION
Russel Stockman, Quechee

COPY-EDITING/PROOFREADING
Keonaona Peterson, Southbridge

PROJECT MANAGEMENT
Rainer Arnold

DESIGN/TYPESETTING
Marion Blomeyer, Rainald Schwarz, Munich

PRE-PRESS/REPRO
Reproline mediateam GmbH, Munich

PAPER
LuxoArt samt new

PRINTING AND BINDING
Passavia Druckservice GmbH & Co. KG, Passau

Bibliographic information published by the
Deutsche Nationalbibliothek
The Deutsche Nationalbibliothek lists this
publication in the Deutsche Nationalbibliografie;
detailed bibliographic data are available on the
Internet at http://dnb.dnb.de.

ISBN 978-3-7774-3306-6

Printed in Germany

ALREADY PUBLISHED

WILLEM DE KOONING
978-3-7774-3073-7

LYONEL FEININGER
978-3-7774-2974-8

PAUL GAUGUIN
978-3-7774-2854-3

RICHARD GERSTL
978-3-7774-2622-8

JOHANNES ITTEN
978-3-7774-3172-7

VASILY KANDINSKY
978-3-7774-2759-1

ERNST LUDWIG KIRCHNER
978-3-7774-2958-8

HENRI MATISSE
978-3-7774-2848-2

KOLOMAN MOSER
978-3-7774-3072-0

EMIL NOLDE
978-3-7774-2774-4

PABLO PICASSO
978-3-7774-2757-7

EGON SCHIELE
978-3-7774-2852-9

VINCENT VAN GOGH
978-3-7774-2758-4

MARIANNE VON WEREFKIN
978-3-7774-3306-6